MW00856663

*Samuel Yellin at the entrance of the Arch Street
workshop, ca. 1926, above. The signature is on
the back of the photo.*

*Endsheets are a pencil sketch of a module for the
firescreen Yellin made for his room, see page 77,
(fig. 153).*

Samuel Yellin
Metalworker

Jack Andrews

SkipJack Press
Ocean Pines, MD

The Yellin Legacy Continues

The gate shown below was used as a corner entrance on the Yellin studio in Philadelphia. (It is also shown in the background of the photograph on page xv.) This gate was stolen from the 5520 Arch Street building shortly after Harvey Yellin's death in 1985.

In the ensuing years since Samuel Yellin's death in 1940, other members of the Yellin family have conducted the business to the present: first Yellin's wife Leah, then his son Harvey, later Harvey's wife Marion, and today Harvey and Marion's daughter, Clare. The building on 5520 Arch Street no longer exists. However, the business is now conducted at other locations.

As a memorial to Harvey Yellin the Third Yellin Foundation Memorial workshop was held in 1986 at the Arch Street Studio to recreate this missing gate. The workshop, sponsored by the Yellin Foundation, was lead by Francis Whitaker and assisted by twelve artist-blacksmiths from around the country.

It was during the First Yellin Workshop, also lead by Whitaker, that Harvey made a remark to Francis and me, which greatly influenced me to write the first editon of Samuel Yellin, Metalworker. Harvey said, "This worshop is just like the old days with father."

The second edition of this book is dedicated to Harvey Yellin, he kept the "Yellin Tradition" alive.

Jack Andrews, 2000

Harvey Yellin Memorial Gate

HARVEY Z. YELLIN	40 YEARS KEEPER OF THE IRON

Enscription on the panel of the gate.

Copyright © 2000 by Jack Andrews

All rights reserved. No part of this publication may be reproduced or transmitted in any form or by any means, electronic or mechanical, including photocopy, recording, or any information storage and retrieval system without the written permission of the publisher.

Library of Congress Catalog Number
00-090605

ISBN 1-879535-17-3

Printed in the United States of America

First Edition, paperback reprint
2 3 4 5 6 7

Notes about the cover.

On the front cover the small photograph is of Yellin in front of his studio, ca 1926. The small photograph of the gates is a commission for C. H. Geist completed in 1926, job # 2695. The grille is one of the many "sketches in iron" from the Yellin collection, ca. 1934.

On the back cover, the photo of Yellin standing by the large gate, is from the Yellin Archives. It is a photo taken during his travels. The quotations are from various sources during Yellin's career.

Samuel Yellin

Metalworker

Preface

Evolution of the Shops

Yellin Wrought Iron

Craftsmanship

Wrought Iron Selections

Epilogue

Appendixes

Introduction

a A newel post and railing on steps leading to the second floor in the Arch Street shop.

There are many examples of milestones and benchmarks that establish a measure for future reference. Occasionally an individual has an impact on culture that creates such a milestone. Samuel Yellin is such a person. His milestone, however, is forged in iron, for he is one of the greatest artist blacksmiths.

This monograph is assembled in recognition of Yellin's permanent place in the history of decorative metalwork and blacksmithing. It will show selections of his work and discuss the factors that made up this great body of work that has created a tradition. It is a legacy of the highest standard.

The Yellin wrought iron made an indelible impression on me when I first saw it. Later it became additionally vital when I realized that there was significantly more that just the iron. Because of Yellin's managerial skills and vision there is an extensive collection of materials which includes: examples of the wrought ironwork, presentation drawings, shop drawings, photographs, negatives and glass slides, journals of the business, quotes, shipping records and business correspondence. There are also a large number of tools, dies, jigs and fixtures which were used to forge and assemble the ironwork. These resources, the Yellin Archives, are owned by Samuel Yellin Metalworkers, Co. and housed in the workshop at 5520 Arch Street, in Philadelphia, Pennsylvania.

Yellin's career is characterized by his complete confidence in the work he was doing. It was as if he knew the importance of his work and the tradition that it would create.

To understand this tradition there are some important factors to consider: his early training with a local blacksmith; his travel, study and work in Europe; and most importantly the four shops that he created and organized. In these workshops he worked with his skilled craftsmen to design and forge the wrought iron. These were the studios where the master trained and guided his men to excel in their work.

The classroom forge at the Pennsylvania Museum School of Industrial Art, where he taught the class in "Wrought Iron," was the first workshop that Yellin organized. There were to be three more shops which Yellin created in Philadelphia. Each was a step in his development, as a man, as an educator, as an artist and as a master blacksmith. A discussion of these workshops is the first part of this book.

The major portion of this book will be devoted to showing the photographs of the wrought ironwork in chronological order from 1909, until his death in 1940. The next section is a complete lecture that Yellin gave in 1926 on "Craftsmanship." Yellin's own words best describe his ethos. The section following this shows photographs of specific groups of iron and the comparison of the great variety of designs. All of the photographs are identified with a number, eg. (#1234). A complete list of jobs can be found in the Job Card Index in the appendixes.

b Samuel Yellin working with his striker (forging assistant) to prepare a demonstration piece, Arch Street forge, 1927.

c Yellin continuing the work as a demonstration for his guest, Arch Street forge, 1927.

d Photograph of Samuel Yellin taken in "His Room" at the Arch Street shop, 1927

The "Notes of Interest" that follows was written by Yellin to be sent to prospective clients and architects to generate business. The choice of sites that Yellin selected in this list is used, in part, as the basis for the selection of the photographs in the section "Yellin Wrought Iron." It also serves to show the incredibly wide range of commissions that he completed during his career, as well as indicating the awards and activities that he felt were an important aspect of his career. It is one of the few autobiographical pieces that he wrote.

Notes of Interest Regarding Samuel Yellin, Esq.

January 27th, 1937

I have designed and executed metal work for the following buildings:

University of Pittsburgh, Pittsburgh, Pa.
Cathedral of St. John the Divine, New York City
J. P. Morgan Residence, Long Island, NY
J. P. Morgan Athenaeum, Hartford Conn.
Henry Clay Frick Museum, New York City
Oberlin College, Oberlin, Ohio
Detroit Public Library
Hall of Fame, New York City
Templeton Crocker Museum, Pebble Beach, California
Grace Cathedral, San Francisco, California
Bok Carillon Tower, Mountain Lake, Florida
Federal Reserve Bank, New York City
Central Savings Bank, New York City
Chase National Bank, New York City
Northwestern University, Chicago
Harvard University, Cambridge, Mass.
Princeton University, Princeton, N. J.
Yale University, New Haven, Conn., including the
 Harkness Quadrangle and Sterling Memorial Library
Vanderbilt Residence, Long Island, N. Y.
Goodhart Hall, Bryn Mawr College, Bryn Mawr, Pa.
Pennsylvania Co. Bank, Philadelphia, Pa.
Washington Memorial Chapel, Valley Forge, Pa.
Art Institute of Chicago
Detroit Museum of Art
Seattle Art Museum
St. Vincent Ferrer Church, New York City
St. Thomas Church, New York City
St. George's Chapel, Newport, R. I.
Mercersburg Academy, Mercersburg, Pa.
James Deering Estate, Miami, Florida

For the past 12 years: all the memorial work for the National Cathedral in Washington, this work being called "Yellin Gothic."

I was also instrumental in bringing important patrons of art to the Pennsylvania Museum. These have contributed to the Museum's fine craftsmanship in metal, wood etc.

The following awards were given to me:

Art Institute of Chicago, 1918
American Institute of Architects, 1920
Boston Architectural, 1920
Architectural League of New York, 1922
Bok Civic Award, Philadelphia, Pa., 1925
Americanization Prize
Pennsylvania Museum School of Industrial Art
 Alumni Medal, 1930
 Art Exhibition, 1916

Contributed to the Encyclopaedia Britannica, two articles on Theory and Practice of Decorative Metal Work.

Lecturer: at the School of Fine Arts and Architecture, University of Pennsylvania, on Design and Craftsmanship.✸

*T*he notes written by Yellin in 1937 begin to indicate the wide range of Yellin's work and suggests the vast amount of wrought iron that he created along with his talented craftsmen and designers. To place Samuel Yellin in the context of the time in which he worked is difficult. Richard Wattenmaker in his definitive article, *Samuel Yellin In Context,* has done this well.

> ...Samuel Yellin (1885-1940) forged a prodigious body of decorative ironwork, handwrought by himself and the blacksmiths working to his designs and directly under his supervision. His work adorns a vast number of public and private buildings constructed in the United States during those years. To appreciate Samuel Yellin's achievement one must grasp not only the personal vision and skill of this inventive and versatile artist-craftsman, but also consider the vast spectrum of revival architecture in this country prior to World War II. Variations on Romanesque, Gothic, Renaissance and eighteenth century French styles determined to a large extent the physical character of our cities, college campuses and residential suburbs during that era. Samuel Yellin's talents were called upon at a moment in architectural history that coincided with the need for monumental metalwork which Yellin himself termed "the salt and pepper of architecture."

> Yellin collaborated with the most prominent revival architects of the day. The list of his accomplishments in the sphere of ornamental ironwork is a lexicon of ecclesiastical buildings, universities, banks, libraries, museums and residences from coast to coast in forty-five states. He undertook large scale commissions in the form of grilles, gates, railings, lighting fixtures and door hardware, as well as miscellaneous decorative accessories of every description, ranging from fireplace equipment to signs and weather vanes. His scope was phenomenal and, unlike many earlier masters, Yellin both designed and executed his creations.

When examining an artist and his work from the past it is difficult to understand the culture and attitudes of that time. Today we might see Yellin's artistry as anachronistic and stylistically out of date. Today we create objects based on different design processes and attitudes. Today we mass produce the details that would be applied to our buildings and used in our homes. It may be that some of these attitudes are being re-examined and becoming part of our culture again. If that is the case then the paradigm that Yellin established is worthy of examination.

Wattenmaker closes his essay with the following:

> ...Samuel Yellin's sensitivity and individuality imparted a personal character to his work. Regardless of historical style, his broad range of experience allowed for multiform variations depending upon the building's needs.

> Almost singlehandedly, Samuel Yellin achieved, during three decades of intensive work, a rebirth of ornamental ironwork parallel to, but independent of, contemporary developments in Europe. He was a man of convictions, boundless energy, masterful organizational proclivities and creative talent. Understanding his artistry can only enhance our awareness of the environment in which we live and aspire to preserve. At the same time his tangible legacy helps us to appreciate what Samuel Yellin contributed to the age-old tradition of blacksmithing, the living craft of which he was so decisively and proudly a part.[5]

Conspectus

This conspectus gives an overview of Yellin's life with some of the personal aspects and the highlights and important features of his career.

1885 – Samuel Alexander Yellin, born on the 2nd of March, in Galicia, Poland, the oldest of four children of Jewish parents Zacharias and Kate Yellin. (Yellin did not use his middle name or initial.)

1892 – Attended an arts and crafts school where he studied drawing and crafts and became interested in blacksmithing.

1897 – Apprenticed with a local blacksmith

1902 – Received his masters certificate. Traveled throughout Europe and worked in shops in various cities.

e One of the many "animals" that were forged at the shop, perhaps by Yellin as a demonstration piece.

1906 – Came to America to live with his mother and two sisters. Studied at the Pennsylvania Museum School of Industrial Art.

1907 – Appointed as an instructor at the Pennsylvania Museum School of Industrial Art, in the metals department. Developed a "Wrought Iron" program and taught this class until 1919.

1909 – Opened his first shop at 409 North 5th Street in Philadelphia.

1911 – Opened a larger shop at 217 Jefferson Street to work on his first large commission, for the J. P. Morgan estate on Long Island.

1913 – Married Leah Josephs, December 25; had two children, Ethel and Harvey.

1915 – Moved to the shop at 5520 Arch Street, which was designed by the architectural firm, Mellor & Meigs.

1915 – Was advanced to the grade of Master Craftsman in the Society of Arts and Crafts of Boston.

1916 – Received the Americanization prize

1918 – Received an award from the Art Institute of Chicago

1920 – Received the Boston Architects award

1922 – Made interior changes to the Arch Street building and added another building adjacent to the shop which was used for the Federal Reserve Bank of New York commission.

1922 – Received the Gold Medal from the Architectural League of New York.

1923 – Received an award from the Architectural Club of Washington, DC.

1924 – Became an American Citizen, completed the largest decorative wrought iron job in the U.S., the Federal Reserve Bank of New York.

1925 – Awarded the Bok Civic Award.

1927 – Wrote "Iron in Art," for the Encyclopedia Britannica, 5th edition, Volume 14, pages 679-681.

1928 – In February employed his largest workforce of 268.

1928 – Traveled to England

1929 – Was appointed as the "Advisor in Metalwork" at the Pennsylvania Museum of Art. Traveled to France and Spain

1930 – Received the Gold Star Award from the Pennsylvania Museum School of Industrial Art.

1931 – Had a serious heart attack. Traveled to Europe to regain his health.

1932 – Laid off a number of workers due to the decline of business and his poor health.

1933 – Alumni Exhibition of his work at Pennsylvania Museum School of Industrial Art.

1936 – Appointed as a Visiting Professor of Design and Craftsmanship at the University of Pennsylvania.

1940 – Died October 3, of a heart attack, age 55.

ʄ *The mottled portions of the photograph are the deterioration of the cellouse nitrate negative of this portrait of a horned anmial.*

\mathcal{A} tribute to Samuel Yellin, his genius and the great body of work that he produced, was acknowledged in the University of Pittsburgh Alumni Magazine:

> It is doubtful if America has ever had an artist whose name more completely identifies itself with a particular type of creative work than the name of Samuel Yellin, the metalworker, whose death on October 3, 1940, brought an end to a career of great force and productivity. Merely the words 'wrought iron' are sufficient to call up the name of Yellin. No man in America came near him in scale of work and robustness of design.

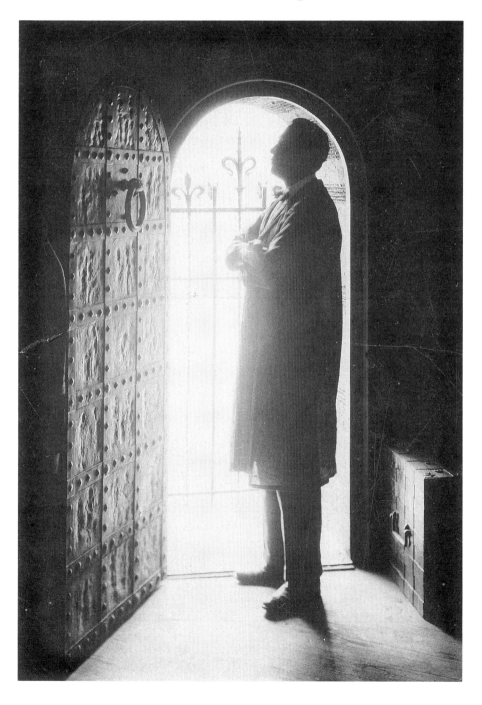

g *Samuel Yellin standing at the door on the north west corner of 5520 Arch Street building in Philadelphia, PA, (see page 78 for photographs of this door).*

Evolution of the Shops

Samuel Yellin was born in 1885 in Mogilera, Galicia, Poland, a small village near the Austrian border. It was an area noted for its crafts and for fine workmanship of wood, fabrics and metals. The details of the early life of Samuel Yellin are sparse. A few statements by Yellin, quoted in publications and stories from the family are all that remain. Perhaps the best way to sum up his early life is with a statement he frequently made, "I was born with a hammer in my hand."

His mother and father, a lawyer of the temple, realized that young Samuel was interested in working with his hands and in making things. They enrolled him in a school that specialized in the arts and crafts, where he was noted for his drawing ability and interest in wrought iron. When he was 12 years old, his father died. His family and teachers, recognizing his talents, decided that an appropriate course would be to apprentice him to a local Russian blacksmith. Samuel eager and enthusiastic to work in the forge of his master, learned quickly. This was the first shop where he learned all the skills required to become a blacksmith. There he became a mastersmith at 17.

He knew that his training should be expanded and that he should be exposed to the wealth of decorative wrought iron available in the major European cities. In 1902 he left home. It is believed that he traveled to Russia, Belgium, Germany, Italy, France and England. During these travels he saw, and he became enthralled with, all the arts. He was especially inspired by the achievements of the Medieval and Renaissance craftsmen and artists. This was Yellin's design and artistic training ground. It was a major part of his creative growth.[1]

After traveling to the great cities and art centers of Europe, he went to Philadelphia in 1906 to live with his mother and two sisters. They had preceded him by several years. He took odd jobs in metal shops around Philadelphia doing minor work in metal fabrication. It was a disheartening period, for he was involved with simple production work, not decorative wrought iron.[2]

Pennsylvania Museum School of Industrial Art

One of the highlights of this period was that Yellin enrolled in the evening classes at the Pennsylvania Museum School of Industrial Arts. (The name of the school was changed to Philadelphia College of Art. Today it is the University of the Arts.) One class was "The History of the Decorative Arts." There is no indication of Yellin's work in that class, but he did one of his earliest pieces of metalwork in a metals class. A photograph (fig. 1) from a 1907 school catalogue shows a project in which he assisted a fellow student. The caption reads: "Weather vane, designed by Carl A. Dubs and executed by Samuel Yellin, pupils of the school."[3]

Although this is not typical of his later work, it does indicate that he was

1 Weather vane designed by Carl A. Dubs and executed by Samuel Yellin

involved with more than just the class in which he was enrolled. While he was working on this project, he came under the scrutiny of the instructor in the metals class. Because of his metalworking skills he was asked to assist the instructor. The next year, 1908, he was asked to develop a new program in "Wrought Iron." The class was started and a forge was built in the carriage house in the rear of the school.

Mrs. John Harrison, the president of the Associate Committee of Women of the Board of Trustees of the Pennsylvania Museum, also noticed Yellin. She donated the money that was used to build and equip the forge. A newspaper article explained that, "Through Yellin's chance coming to the school and stimulation of the metal program, a great change came over the workshops...the practical teaching of the forge work not only increased Yellin's efficiency and made his artistic growth possible, but had made this department of the school one of its most important."[4] He taught on Monday and Wednesday from 7:30 until 9:00; the pay was $3.00 for an evening.

He was 23 years old and was teaching a class in wrought iron only five years after leaving his home in Poland. It is certain that this experience was of great benefit to his development in his language skills, his critical skills and his design skills. As a teacher he had to explain tools and techniques and evaluate the work of students. In a remark at a lecture, Yellin commented that this experience of working with students was an important aspect in the development of his critical abilities and of his artistry. It certainly was a continuing part of his education and it enabled him to work easily with the many people, associated

2 An exhibit of student work of the "Wrought Iron" class, ca. 1912

with the arts, with whom he was to meet. The doors of clients and architects were now being opened to him. The Pennsylvania Museum School of Industrial Art formed a focal point where he met many of the artists and craftsmen with whom he was later to work on many commissions. For example, Nicola d'Ascenzo, a student of the school in leaded glass, later collaborated with him on several jobs: the Valley Forge Chapel (#1377) and the St. Mark's Church (#1962). It also helped him to meet patrons. For example, in a photograph (fig. 10) there is a small plaque propped up on the ledger books to Yellin's left. The inscription reads, "In Memory of John Harrison, 1834-1908, by His Wife Emily Leland Harrison." There is also a larger associated plaque on the floor behind the typist. Mrs. Harrison, as noted previously, gave the funds to create the forge at the Museum School.

He continued to teach these classes until 1919, at which time Parke E.

Edwards, a former student, taught the class for three years. Edwards went on to design and execute the work at the Bryn Athen Cathedral in Abington, PA.

From 1923 until 1926, Joseph Konetsky, Yellin's superintendent at the Arch Street workshop taught the class. However, Yellin was still interested in education and came in frequently to demonstrate and lecture at the Museum School. Many of the men and women in these classes were greatly influenced by the force of Yellin's teaching.[5] A number of these former students either came to work for Yellin or set up their own shops.

5th Street, the Start of the Business

Although the experience at the Museum School was wonderful, to work at menial, metal fabrication jobs was disheartening. He was always wishing for his own place to work. After three years of saving and planning, Yellin opened his first shop in 1909 with capital of $150. It was in a rented apartment on the top floor of a tenement building, on 445 North 5th Street. He later said about this shop, "At last, I found a garret on the fourth floor at Fifth and Wood Streets, two little rooms under one roof. You see I started at the top. Not just what I wanted, but cheap and I couldn't afford much rent....A place of my own at last! Where I could do the sort of work I loved....That day I started to smile."[6]

He employed one helper to start. The rooms were small, the ceiling was low

3 Workshop on 445 North 5th Street, Philadelphia, PA

and there was inadequate ventilation. There were the constant complaints of the other tenants angered by the smoke and noise. This created tension!

A number of workbenches were placed around the room (fig. 4). It seems that a dividing wall had been removed to give a more open space. In one photo, (fig. 5), there were five workers along with Yellin working in this room; it is not the same room as in another photo (fig. 6). It is obvious that there was a need for more space. It is unclear how long Yellin worked in these quarters.

We can deduce that Yellin rented more rooms next to the 5th Street shop, because in the photograph of a railing (fig. 7), a title can be seen at the top of the photographic background, "Photographs of Wrought Iron Work, Made for Various Architects by The Industrial Ornamental Forge Co., 445-7 North Fifth St. Phila. Pa." (This is the only photographic background with a description printed on it; all later photos were annotated on the back with a typed description.) His first forge was named the "Industrial Ornamental Iron Co.," undoubtedly due to his association with the Pennsylvania Museum School of Industrial Art. The name of the shop was to change several more times. The photographs were taken in the same small drafting room, since the railing can be seen hanging from the iron straps holding the shelving for the drawings.

A letter dated September 25, 1910, from 3140 Page Street, Philadelphia, indicates that this was his office and possibly the drafting room. It was combined with his home and was used for a number of years. The design and draft-

4 5th Street shop, Yellin working on a column in the center, above left, (photo B. Wallace)

5 Assembly room in the 5th Street shop, Yellin is observing work in progress, above

6 Yellin at the drawing board second from left in the drafting room at Page Street studio, below left

7 Page Street studio used as a photographic studio; an unidentified iron railing, below

ing functions were an important and integral part of the work in the forge. It was one of the operating principles that Yellin established early in his career. From the photograph of the first drafting room (fig. 6) it is interesting to see the reference material spread around: drawings, plaster casts and photographs. He stated about the working conditions, "Yet with all my hardships and worries I was happy for I was doing the work I loved."[7]

We can examine these early photographs today, because Yellin established a

8 The office on Page Street with Yellin in the foreground, (photo by B. Wallace)

standard that he used from the very beginning of his career. This was to document and photograph every piece of ironwork before it left to be installed; then, maintain those records. Setting up a white wall and titling the background in such a small studio indicates the importance that he placed on recording his work.

Architects and clients were telling Yellin to visit other cities that would have larger jobs and greater possibilities. They supported him by writing letters of introduction; an early example of this is a letter of recommendation dated November 1910, written by Charles Barton Keen, an architect in Philadelphia. It is written to "The architects in Boston;" it states that the "artistic work of Samuel Yellin" and his reasonable prices are highly recommended. This letter and others like it led to many commissions.

Mr. Miller, a teacher at the Museum School, recommended Yellin to Frank Miles Day, who was greatly pleased to find someone to do "artistic ironwork." Later, it was Day who arranged for Yellin to go New York and meet with some of his colleagues. He also wrote letters of introduction to them. The trail of these introductions leads from one important architect to another: from Day to Medary, then to Cass Gilbert, then to York and Sawyer.[8] The critical turning point came with Day's introduction of Yellin to the office of LaFarge and Morris in New York. When Yellin visited the office, he attracted a great deal of attention with the wrought iron samples and drawings that he presented to the architectural staff of the office (he had just purchased a new overcoat for the occasion). At that time, the LaFarge office was working on a major job for which they had sent drawings of an iron gate to be fabricated in England. The staff was impressed by Yellin's work and a wire was sent to cancel the order. Yellin had his first important job.

This was in January of 1911 and there were seven men in the shop. The architects at the LaFarge office were concerned that Yellin could not deliver the work on time. In an informal talk years later, Yellin commented on this turn of

events. "To fulfill such an order I had to build a big organization....We worked day and night, scarcely taking time to eat or sleep. But the gates were finished on the date promised."9

217 Jefferson Street

To accommodate this "big organization" required more space and better facilities. The business moved to a new building on 217 Jefferson Street. The name was changed to "Samuel Yellin, Art Metal Worker," a definite shift of emphasis with the change to "Art Metal Worker."

In the Jefferson Street drafting rooms (fig. 10) there is considerably more space and a much more pleasant atmosphere. In the forge area (fig. 11) there are three forges in operation. The assembly area (fig.12) is larger and has a number of interesting wrought iron jobs in progress. The work load continued to grow and more staff were hired: 19 at the end of 1912, 24 at the end of 1913,

9 Yellin top row left with Jefferson Street workforce, below left

10 Yellin second from right in the drafting room on Jefferson Street, below

29 at the end of 1914. With Yellin's reputation well established, the number of employees steadily increased to 268, its peak, in 1928. (See page 115 for a chart of the number of employees.)

By viewing the development of these early shops, we can deduce several important principles about the Yellin method. An operating system was established and was proven to work well. Design was a critical and central part of the process. It was important to him to have proper space and equipment. The best of materials was always acquired; he regularly tested the wrought iron as it came into the shop. It was important that he have the proper staff and trained men to operate all aspects of the business. Because of the shop's reputation, qualified craftsmen constantly sought employment. They were from all nations; the shop was truly an international studio.

It was Yellin's leadership and managerial skills that he used to weld all of the people and the principles together into a wonderfully functioning workshop. It is when the move to Arch Street takes place, in 1915, that all of these elements have been tested, and are now fully functioning and orchestrated by the "Maestro" (the name given to Yellin by the men in the shop).

5520 Arch Street

11 *The forge area, Jefferson Street, above*

12 *Finishing and assembly area, Jefferson Street, above right*

13 *Looking west at the front entrance to 5520 Arch Street, Philadelphia, PA, below*

14 *Facade of 5520 Arch Street, below right*

With this next move the shop name was changed to "Samuel Yellin, Metalworker." The name that Yellin used for the remainder of his career. Yellin frequently said, "I am a blacksmith." This simple and understated description was reflected in the name of his workshop.

Because the demand for wrought ironwork was good and more jobs were anticipated, Yellin envisioned a new, more spacious shop to be designed to his specifications. He admired the Spanish style of architecture; he wanted atmosphere and character, a place where he could meet clients and friends and show his wrought iron in a proper setting. Mellor and Meigs, an architectural firm that specialized in residential structures, designed his new workshop.[10] He had developed a close friendship and good working relationship with Walter Mellor and Arthur Meigs. The workshop was one of the few industrial buildings that

they designed, but it was designed along the lines of a Spanish urban estate. (See page 30 for more details about the the Mellow and Meigs office.)

Upon entering the front gate, at Arch Street, you walk through a covered walkway which turns to the right, and leads into the office. (This was later changed into a hallway.) An interior gate is opened, if you can operate the two cleverly hidden latches, and you enter a large room that Yellin called "My Room." This room has a high beamed ceiling, wooden floors and stucco walls. The ceiling between the beams is painted vermillion, Yellin's favorite color. The walls are covered with a variety of etchings, paintings, tapestries and antique

15 Gate in walkway at 5520 Arch Street, below left

16 Entrance hallway, with Yellin seated in "My Room," below center

17 "My Room," looking to the north east, below

18 "My Room," looking to the north west toward the corner door, left

iron. This was the room that Yellin used as an office and meeting room to greet friends, clients and architects. It was his stage. From here he directed a wide variety of activities and created an epic play of wrought iron.

Yellin's room evolved and changed over the years. The character became richer and more mellow as different artifacts were added. The stucco walls became darkened from the fireplace smoke and the ash from the forges. The iron acquired a glowing patina with age. The romantic quality that Yellin wanted has become richer.

On the first floor in the rear of the building was the forge, a few steps from

19 Forge area on first floor, 5520 Arch Street, Yellin in center with neck tie

the hallway. Entering the forge you see a row of work stations with anvils and forges. Overhead line shafts drive blowers for the forge air and for the draft. Opposite the forges were the large power hammers on the same line shaft. On the floor, apprentices would set up the frames of a gate. The head blacksmith, at each work station, directed his striker (the blacksmith's helper) on the work to be done. Yellin at the next station would review the work on a large scrolled piece. Konetsky, the superintendent, just behind Yellin, watched. It was Konetsky's responsibility to manage the workshop and to make sure that all of the departments worked together.

This photo (fig. 19) pre-dates 1922, when the museum was added to the left of the power hammers. In the museum was displayed the collection of antique iron that Yellin had collected in his travels to Europe. The collection was a vital element in the design of Yellin's work, since he regularly referred to it and used the examples of fine wrought ironwork to show to his designers and draftsmen (fig. 21).

On the second floor in the front of the building was the drafting room (fig. 20). In this room we see full-size drawings of several major commissions being drawn. These full-size charcoal drawings were hung on the wall to the left. In this way, clients, architects and the Yellin staff could view the work as it would look installed. The drawings were stored in file cabinets and flat drawer files for easy reference.

The library (fig. 22), just off the drafting room, served as an important

research area for the designers. Almost all of the books in the library were on subjects concerning design and art from different countries representing varied artistic styles and time periods.

There were other occasions on which the drafting room became a party room. For example, he room was set up for the 20th anniversary of the Yellin shop in 1929. At other times the room downstairs (fig. 23) was used for dinner parties honoring guests and clients. There were also dinners at Christmas and other holidays. Many times the staff from various architectural firms were invited for dinner. Later they all went out for an evening of bowling.

20 Yellin on the left in the background of the drafting room, top left

21 Yellin pointing out important features of the antique iron collection, top right

22 Yellin, on the left, in the library with the designers and draftsmen, bottom left

23 A party for the superintendents in the shop along with special guests, bottom right

On the second floor to the rear of the building were the assembly and finishing areas. Various machine tools and equipment, along with a wide assortment of hand tools, were hung on walls and on the work benches. The work benches lined the east and west walls of this floor. Each worker had a bench work station. They worked together on the fitting, assembly and finishing of the work. Large, heavy jobs were fabricated on the first floor.

As you see the layout of the total workshop, you begin to grasp an image of Yellin moving around, working with the designers and draftsmen, explaining the best way to do the work. He talked to the superintendents in the various

24 Second floor assembly at 5520 Arch Street

departments, undoubtedly scheduling work and arranging various tasks throughout the shop. He also would be on the shop floor, attending to the myriad details and all of the critical elements that he had to deal with personally. With the office group he would be scheduling shipments of materials and supplies and preparing to send out finished work. He would be scheduling visits of

25 Forge and assembly area on first floor of the building adjacent to the main building

clients and guests, as well as checking on income and payments. A memo labeled "General", and dated June 20, 1930 in the files sets the tone of this procedure. "All drawings, no matter what they are, in sketch form, when they are completed, must be hung up on the wall, so that Mr. Yellin can see everything without having to ask for drawings, in order that nothing may be overlooked. Please see that this is carried out. Samuel Yellin."

This may sound like an unnecessarily disciplined manner of working, but Yellin was trained in the manner of the medieval craftsman. This dictated that all workers in the guild produce work worthy of the order. They were all working together with a sympathetic, helpful attitude towards each other. But, Yellin realized he was also a tough task master, for he was quoted as saying, "I'm afraid I am hard to get along with. I go into the shop and watch the boys work and sometimes I make them throw away what they are doing and start over again. Then maybe I don't like that and–more changes. But after a while it is finished and then it is perfect."[11]

Francis Whitaker, one of the "Deans of Living American Blacksmiths," worked in the Yellin forge. He relates what the work experience was like.

> I had the good fortune to work at Yellin's for a year, it was in 1922, the Federal Reserve job was well underway, a new building across the street was just completed. There was nothing he could not do as a smith. He would work with one man until the results were perfect in every phase; design, forging, assembling, and finishing. Perfection was our goal; we were inspired by this great man. Work that was not up to standard was not let out of the shop. It was reworked or done over. Nothing escaped his eagle eye.[12]

Realizing that most of his clients were in New York City, Yellin opened an office in the Ligget Building, on 41 East 42nd Street. It was a small office with an apartment from which Yellin and various members of the firm could make calls and visits. Advertisements were placed in architectural journals and magazines that related to his work (fig. 27).

The Beaux-Arts training and European education of many of the architects of Yellin's time undoubtedly made them more sympathetic to the style of work that he was interested in creating. This was the period when Yellin was able to establish strong working relationships and develop friendships with many architects. He felt strongly that architects held the key to his success, for it was on their buildings that his ironwork was to be placed; thus, he saw the architect as the critical design leader of the entire project. Even though he was in complete control of all of the parts for which he was responsible, he was able to see the total design and integrate his ideas with that image. In no way was he subservient to the demands of others, nor did he bow to their demands; he simply realized that the architecture was the background on which his ironwork was to be placed and that he had a responsibility to do it in the best possible way.

> The architect...should be the great coordinator, as well as the structural designer, presiding over all the crafts and bringing all the various craftsman into an alliance with himself. In other words, the craftsman should work with and not for the Architect, for though the former should be willing to merge his identity, contributing his best efforts to the furtherance of some great artistic unit, he must be allowed to preserve his personality and freedom of expression.[13]

Yellin relates the manner in which he worked with James Gamble Rogers on the Harkness Memorial at Harvard and with York and Sawyer on the Federal Reserve Bank of New York, emphasizing the intimate and sympathetic relationship in the design process. It was the creative give and take that allowed

26 Yellin at the front gate, 5520 Arch Street,ca. 1927

27 An ad placed in the magazine "Cathedral Age," in which there was an article on the Yellin wrought iron in the Washington Cathedral

Samuel Yellin

METAL

WORKER

**5520 Arch Street
PHILADELPHIA, PA.**

**41 East 42nd Street
NEW YORK CITY**

both architect and craftsman to put forth their best efforts. Yellin stated in an article that, "It is this spirit of camaraderie between architect and craftsman that develops a true conception of organic architecture and makes possible its final accomplishment."[14] There was no expediency nor compromise when it came to the work in the shop. To summarize Yellin's work ethic, a 1924 magazine article quoted him as saying:

> I cannot afford to do anything inferior to the best I know. Whatever leaves my shop must satisfy my conscience. It must mean something. I care not in what medium a man works; be it wood, or stone, or wallpaper, it must be suited to the meaning he wishes to convey. The work and the workman must be real.[15]

When examining the attitudes, processes and manner by which Yellin designed and created his work there are many intertwined aspects that establish a foundation for understanding his philosophy. It is difficult to rank them, or to establish clearly which was the most important tenet to Yellin. However, there is one fundamental principle which sets the foundation for all of Yellin's work. He frequently stated, "When an architect asks me to submit specifications for a contemplated piece of ironwork, my answer is: 'I shall specify that it is to be executed in the best possible way.'"

He also referred to a quote by John Ruskin, "When we build let us think that we build forever." This thought is the basis of his philosophy; it is the foundation. From this and his background experiences, one can begin to sense how Yellin designed his work and what were the important factors used in the creation of that work.

There are other principles from which can be grasped the ethos of this man. The first tenet is that he was totally absorbed and enthralled with the material, wrought iron. Working with it was second nature to him—it was as if it was part of his being. He responded to iron empathically when forging and so it flowed naturally. He simply reacted to the design situation with his rich background of information and extensive knowledge. One of his most frequent quotations was: "I love iron: it is the stuff of which the frame of the earth is made and you can make it say anything you will. It eloquently responds to the hand, at the bidding of the imagination."[21] He was constantly absorbed with the material, iron, with how it should be used and with the tools and processes to form it. He continually emphasized this point:

> The craftsman's first preoccupation should be with learning the capabilities and limitations of his material...Iron, for instance, it is the least expensive of all materials, and there is no material that lends itself as readily to beautiful treatment, none that can be worked more quickly...both design and material must be employed in a manner suitable to their nature.[16]

There is no question that he was smitten with wrought iron and that he was facile with forging wrought iron. This would give him considerable confidence and substantial facility in creating anything that would come to his imagination. In the early years, he was trying all types of forging techniques and styles, but in later years, he was working from a wealth of knowledge and experience and created incredible new forms, methods of joinery and wonderful techniques, all brought together in masterful harmony by this acquired knowledge.

Another precept of his professional ethic which he regularly stated in lectures and conversation, was that "much can be done with the hammer that cannot be shown on paper." He was always insistent that the place to do the creative work in iron was in the forge heat and at the anvil. This was empha-

sized by repeatedly admonishing that, "There is only one way to make good decorative metalwork and that is with the hammer at the anvil." He sometimes referred to this when he commented about a piece that he had created at the forge. He said that he "sketched it with the hammer."[17]

Frequently, Yellin sketched his ideas on bits of scrap paper. Later, these ideas would be forged in iron at the anvil. Harvey Yellin relates how some these drawings were created. "Father would work late into the night, lying in bed, creating the ideas and making sketches that he would take into the shop the next day and produce them in iron." However, after his heart attack in 1929, Yellin no longer worked at the anvil. He would have his best smiths produce these ideas in wrought iron. Much of this type of work was done in the 30's, when there were few commissions in the shop.

Drawing with a hammer was the manner by which much of Yellin's creative work was done. Yet, all of the work in the shop had to be drawn to communicate accurately the details to others so that it could be produced. The drawings were the master plan used to maintain an orderly process within the shop. It must be emphasized that the shop drawings were an absolutely critical element in the working processes of the shop. After the design ideas were established, drawings would be made for test pieces, the size of materials selected and the

28 "Sketch in Iron"

29 "Sketch in Iron"

overall size relationships of the piece established. While this was being done, it was compared to the architectural drawing of the job. When the overall design was agreed upon, the site would be surveyed by men from the shop, to establish accurate dimensions of the actual site. At this point the finished working drawings for the ironwork would be completed. Work on the iron would be started after all of these elements, dimensions and details had been checked and rechecked. Yellin demanded that there be no dimensional mistakes in the ironwork; when the iron was delivered to the site, it was to be installed without fitting problems.

Yellin considered the design of any piece of work to be a unified design within itself, but also he firmly believed that the ironwork must relate harmoniously to other parts of the design and to the environment in which it was placed. He stated, "It is most important that a piece of work shall be harmonious from every point of view. I mean that, besides being a part of its surroundings, it must harmonize within itself."[18]

He was also aware of the needs and wishes of his clients. When he began work on a memorial railing, he inquired about "the personal characteristics and tastes of his clients." He wanted to know what they liked. Learning that Mr. George was born and grew up in England, he introduced the rose, the acorn and oak leaf into the design (fig. 156, pg. 79). Mrs. George's love for nature and all living creatures was symbolized in the bird forms.[19]

Another principle that Yellin strongly adhered to was that the great art of the past was important for one to study and understand. When Yellin traveled abroad on his frequent trips, he purchased books and ironwork of all types. These would be brought back to the shop and set up in the museum. The scope of the library and of this collection showed Yellin's interest; it was distinctly of the past.

There is much talk today about modern art, the new spirit, and the creation of something entirely different from what we have ever had before. I do not think that art is a thing that can be invented. A creative artist will naturally work in the spirit of his time, reflecting the needs and idioms of his own epoch but I feel as did William Morris when he said: 'I do not think that any man–could do anything in these days without much study of ancient art.' By this I do not

30 Charcoal study drawing of a grille for the Sterling Memorial Library, Yale University, 1929 (#2941)

mean a slavish imitation or repetition of old things that were created in a different age, under entirely different circumstances; but I do believe that by studying and seeing the splendid examples of master craftsmen, one forms an idea of a precedent–a worthy background of tradition from which the most fruitful results may spring.[20]

One of the books purchased by Yellin on these trips was the important edition by Violet-le-Duc.[21] In figure 32 a drawing of a grille from one of these volumes is shown. This design was used for an early job in Philadelphia on Spruce and 17th Streets (fig. 31).

Another example of the designs of the past which influenced him is the fragment of early Gothic iron fragment (fig. 33) purchased in the 1930's while Yellin was on a visit to France. The copy of that piece (fig. 34) was made by Yellin's smiths on his return. It is not known if this example was used in any projects, but other iron samples were used in various projects. Many of these were used in studies which were installed in the Arch Street workshop.

31 Grille, Spruce Street ,Philadelphia

32 Drawing of scroll from Violet-le-Duc

This type of copying may seem like plagiarism, but Yellin did this for two reasons. The first is that he wanted to study the design and improve the technique of making the piece.[22]

This awareness of the past and the ability to interpret it in the architecture of the day is reflected in an article by Philip Frohman, architect for the Washington Cathedral. "He is one of the few living artists of whom it may be said that, in beauty and logic of design and in perfection of craftsmanship, his work is fully equal to the finest achievements of the Middle Age. Among the various arts and crafts which have been employed in the building and adornment of Washington Cathedral, we believe that the highest degree of artistic merit thus far attained will be found in the wrought work of Samuel Yellin."[23]

With this great knowledge of the artwork of the past, Yellin was impressed with one particular decorative motif. Although he used many decorative patterns on his iron, it is the dot and chevron and its multitude of variations that he worked with most frequently. This is a decorative theme that has been used throughout the history of the arts. Look to any ancient civilization and the dot and chevron or its variations will be found. Some of the first examples of the Yellin's application of this decorative motif can be documented from the early ironwork at the 5th Street shop. It was used from a small scale to a large scale. The way this motif was designed for the Packard Building 10-ton gate in

33 Fragment of French Gothic iron, left

34 Reproduction of the fragment, right

Philadelphia, (#2213, pg. 36), show this usage. The iron cross members at pedestrian level are decorated with this pattern with small incised marks about one inch long. The entire panel across the top of the gate repeats this pattern. The individual dots are large hemispheres ten inches in diameter; the chevrons are diagonals about eighteen inches long.

It is interesting to speculate what this motif meant to Yellin and why he worked with it so frequently. Imagine the discussions that Yellin had with Mellor & Meigs when they were starting on the design of the Arch Street building. The frieze around the top of the building is a variation of that pattern (fig. 14, pg. 7). It might seem that if it was only on a few of his works that it was just a passing fancy. Was this a signature?

It is interesting that an illustration in Geerlings' book, *Wrought Iron in Architecture*, that refers to several illustrated variations of this motif, with the notation "the most usual historic design." Yellin encouraged Geerlings to write this book on wrought iron and assisted him with the descriptions of the forging processes.[24] (Geerlings was working, as a junior architect, at the York and Sawyer office when the Federal Reserve Bank of New York was built.)

There is no doubt that Yellin had a great influence on the younger generation of the time, whether it be metalworker or architect. His impact was felt by his colleagues and friends. The remarks and statements made his contemporaries speak of their reactions and feelings about their friend and companion. One such statement is by George Howe, an architect who in 1918 joined the firm of Mellor and Miegs.

It is an unfortunate fact that the real nature of craftsmanship, the use of materials in a way appropriate to their nature, for ends to which they are well adapted, is little understood today, not because there is any dearth of information on the subject, but because the perfection of the mechanical means of production at our disposal has blinded us to the simplicity of the means which produced the great works of the past, and has led us to admire tricks of legerdemain, and illusions, by which one thing is made to look like another, and materials are loosed from their proper sphere to be discovered again in another, and foreign

CHISEL-MARK ORNAMENTATION

a. THE MOST USUAL HISTORIC DESIGN

AMONG INNUMERABLE OTHER POSSIBILITIES ARE:-

A TYPE OF GROTESQUE HEAD

FOUR STAGES OF DEVELOPMENT —

35 Dot & chevron used on door hardware, Albert Isham residence, 1927, (#2746), left

36 Ilustration from Geerling's book, above

one. To add to his difficulties, the craftsman is constantly asked to slur over that which is deemed unimportant, or which will not show, and is urged to make his work as cheap, yet as showy, as possible. Against this tendency, Samuel Yellin has steadfastly set his face.[25]

The tenet that ironwork should be inviting and not a barrier is more difficult to put into actual use. The natural uses of wrought iron are as protective devices and restraints. Many consider that a grille for a window is meant to be a security device to keep people out. Yellin saw this in an entirely different way. He stated that in this country, "iron is used as a barrier not a bridge." He was always concerned with making a visual bridge from the people to the building or place where it was used. He was concerned with establishing a human scale for the architecture.

Another part of this notion is the use of visual devices to interest the viewer to react with the entire work. It seems that with each of his major works there are elements that invite you to participate in the work. For examples many elements can be felt, turned, twisted or pulled. Much decoration and imagery excites the imagination and allows you to view the piece for an extended time. This imagery was wide and varied, for the smiths in the forge continually created new and varied animals and gargoyles. It maybe that the earlier statement "iron is the salt and pepper of architecture" sounds like a superficially applied decorative technique, but Yellin was greatly concerned with not only the structural aspects, but also with the overall harmony of the ironwork. He was concerned with the visual devices that could bring people into awareness of the architecture. Of course, the overall design was the most important element, but the use of the animals, dot and chevron and the other decorative techniques were part of the overall harmony.

In some types of metalwork decorative designs are applied in a very light fashion. An example is incising in which the design almost seems to be drawn on the surface. Yellin used incising to heavily work the surface with deep penetrations, creating a much more three-dimensional piece. Another example is joining iron parts together, Yellin used collars, rivets and tenons to show how the pieces were assembled. The fasteners were not hidden, because they were part of the design.

With much of Yellin's ironwork the forging processes are apparent. This makes it easy for you to understand how the part is made, but upon closer examination you find an entirely new way in which a simple process has been used to create new form. In other examples there are no easy clues to see how

the piece was forged or assembled. It is not until the part is turned over or examined in another way, that the manner in which it was made becomes apparent. In some cases the forging and assembly processes are a mystery.

With most of the Yellin ironwork the force of the virtuosity becomes apparent and is simply overwhelming. Every Yellin wrought iron piece has on its own personality, charm and mystery. It is truly iron art.

As a result of this artistry during his career, Yellin received many awards and citations; recognition came from many sources. He was also widely recognized by the press and he was always excited by this recognition.[26] One such recognition of his artistry stated:

> He constantly demonstrates his idea of how great art can be made adaptable to human needs. He possesses the genius of recreating, transforming, and combining historic designs in such a way that their beauty takes on a new form and new meaning, and to become peculiarly fitted to the exigencies of the present.[27]

How the wrought iron majesty of Samuel Yellin will be received by future generations is unknown, but let these pages serve as a milestone and record of his work and artistry in wrought iron.

37 Yellin, sixth from left, standing with the men of the workshop, ca. 1926

\mathcal{Y}ellin Wrought Iron

\mathcal{T}he following wrought iron commissions have been selected to show the progression of the ironwork that Samuel Yellin completed during his career. They have been placed in chronological order to reflect the growth and development of this body of work.

38 Cyrus H. K. Curtis residence, detail of scrolls and hardware on gate, ca. 1910, (no job #), left

39 Cyrus H. K. Curtis, fragments of gate photographed in the drafting room of the first Yellin workshop, right

40 Cyrus H. K. Curtis residence, entrance gate, below

The gate below is the first part of the commission of wrought iron done for the J. P. Morgan estate on Long Island. A later front gate and entrance is shown in fig. 48. The back drop material used in this picture is a full sized drawing from another project. The young man below can also be seen in the photograph of the men in the Jefferson Street shop (fig. 9).

41 J. P. Morgan estate, 1911, (no job #)

42 *F. A. Seiberling, entrance gate, (no job #)*

43 *F. A. Seiberling, gate detail, left*

44 *F. A. Seiberling, interior door pull, right*

45 *Henry Clay Frick, lunette over entrance door below (#1322), top left*

46 *Henry Clay Frick, entrance door (bottom portion of photograph damaged), bottom left*

47 *Henry Clay Frick, entrance door detail of door hardware, below*

48 *J. P. Morgan estate, entrance gate, 1914, (no job #)*

49 *Senator in Wilmington, 1914, (no job #)*

50 McNair residence, front door entrance, (#1361)

51 McNair residence , spiral staircase with railing and lamp, 1915

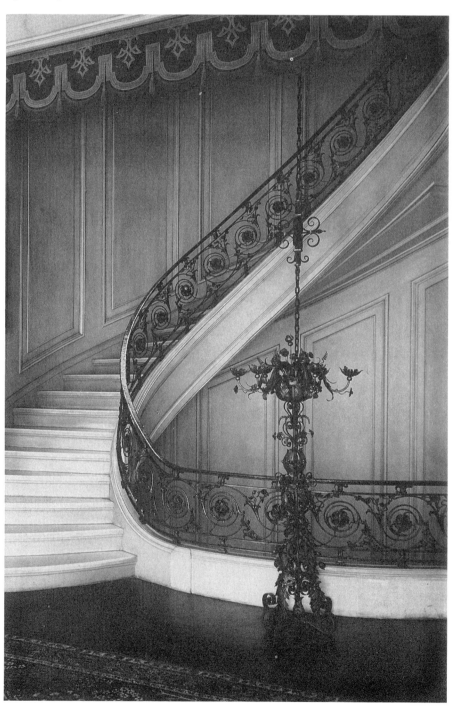

52 Deering estate, entrance gate to Vizcaya, 1916 (# 1502), (photo Mooney)

53 Deering estate, arched gate, lower left

54 Deering estate, detail of the interior iron motif, lower right

55 Columbia University, entrance gates, (no job #)

56 Oberlin College, interior gates, 1917, (# 1563)

57 *Washington Memorial Chapel, entrance gates, 1918, (#1377)*

58 *Ford Building, one leaf of an exterior door, 1918, (#1658)*

59 Entrance door of the Mellor and Meigs office. There were no job numbers nor were any of the photographs of the work for the office dated.

61 Fire screen for the home of Arthur Meigs, (#2285), below left

60 Door knocker used as a towel ring in the Mellor and Meigs office. above

62 Photographic set up for a floor light for George Howe, below

The wrought ironwork Yellin did for the Mellor, Meigs and Howe office was done gratis. In the same manner, there was no architectural fee for the design of the Arch Street building.

The only indication of charges were on the personal items, such as the fire screen above. There was usually a lively interchange about the price being to little. The architects saying it should be more; Yellin insisting that it was too much and he would gladly do it for nothing.

In fig. 61 it can be seen how the iron was photographed before it left the shop. Note that the cloth background is being moved to eliminate wrinkles.

63 St. Vincent Ferrer, screen, 1918, (# 1629), right

64 St. Vincent Ferrer, candelabra, left

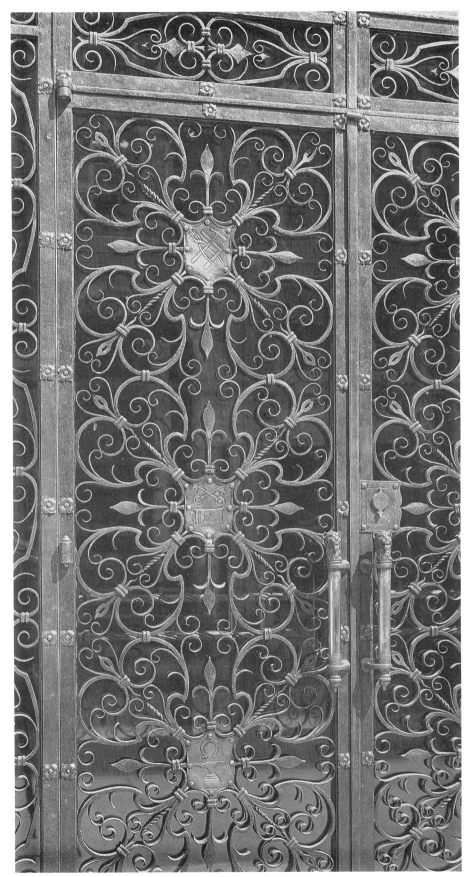

65 Hardware Mutual Fire Insurance building, detail of entrance doors, 1921, (#1922)

66 Hardware Mutual Fire Insurance building facade

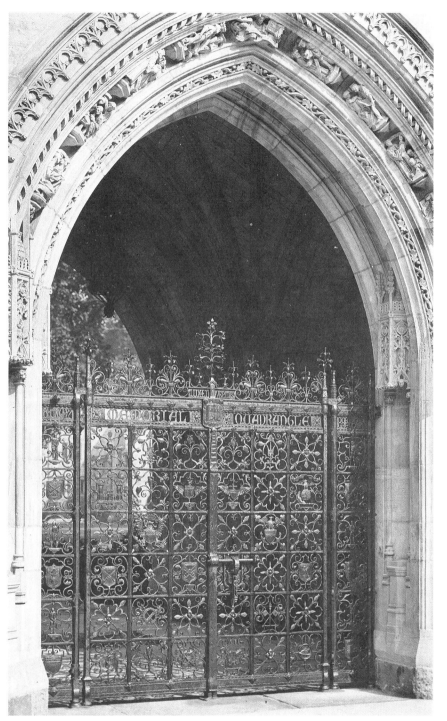

67 *Yale University, Gallery of Fine Arts, 1928, (#2742), above left*

68 *Yale University, Harkness Memorial Quadrangle, 1922, (#1982), above*

69 *Yale University, Sterling Memorial Library, 1930, (#2941), below left*

70 *Federal Reserve Bank of New York, lamps, 1922, (#2182), top left*

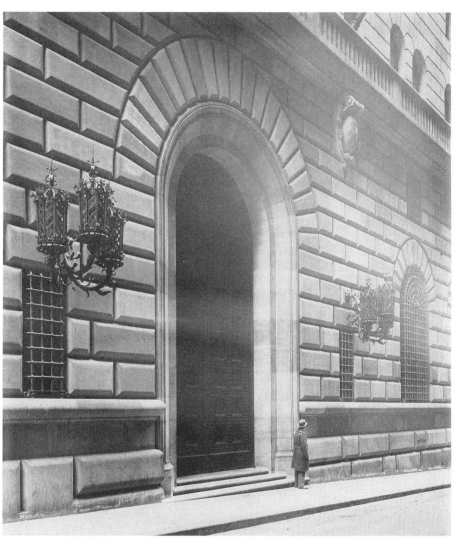

71 *Federal Reserve Bank of New York, main entrance, top right*

72 *Federal Reserve Bank of New York, grille, above*

73 *Federal Reserve Bank of New York, teller's grilles, bottom right*

The Federal Reserve Bank of New York may be the largest commission of decorative wrought iron in the modern world. When it was completed in 1924 two hundred tons of decorative wrought iron had been installed in the bank. The job started in late 1921 and was finished three years later. Initially the number of men in the shop was around 74 and at the end of 1924 there were 178 employees. In 1922 an additional shop was built alongside of the main building. Special forges and power hammers were installed; it is believed there were 60 forges in operation in this new shop. This addition was demolished in the 1960's as part of an urban renewal project.

Althought this was Yellin's greatest commission, the largest single assembly of wrought iron was the McKinlock Memorial for Northwestern University, (#2864, pg. 56). It was 29 feet tall and 26 feet wide. The heaviest assembly was the gate for the Packard Building (#2512), shown on the next page, estimated to weigh 10 tons.

74 Federal Reserve Bank of New York, interior court

75 Federal Reserve Bank of New York, interior screen and gate

76 Packard Building, entrance gate, 1924, (#2313)

77 Packard Building, lantern, installed after the photograph of the entrance gate was taken

78 *J.E. Aldred estate, entrance gate, 1923, (#1603), above left*

79 *Oberlander residence, window grille, 1925, (#2448), above*

80 *Bulletin Building, delivery gate, 1924, (#2302)*

81 Philadelphia Saving Fund Society Bank, entrance gate, 1926, (#2512)

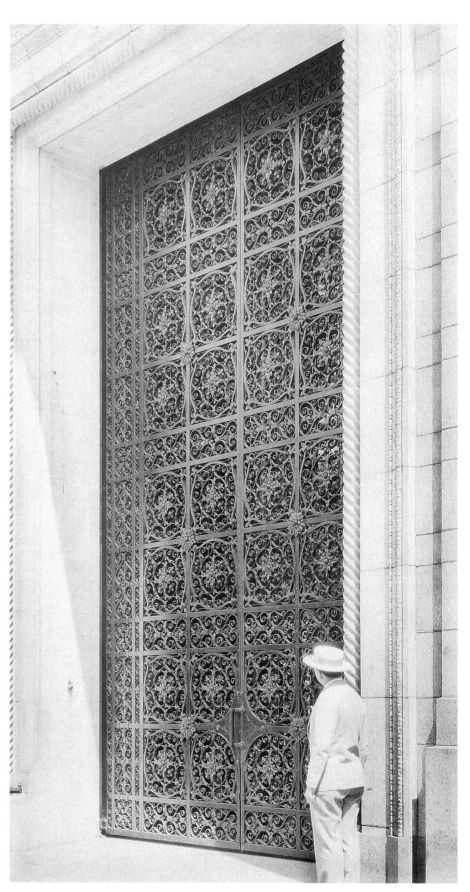

82 U. G. I. Building, sliding gate, 1926, (#2585)

83 Mercersburg Academy, pulpit, 1926, (#2614)

84 St. Mary's Church, pulpit and stairs, 1927, (#2639)

85 Union Central Annex Building, lamp and bracket, 1927, (#2714)

86 Washington Cathedral, candlestick, 1927, (#2593)

87 Washington Cathedral, St. Mary's Chapel, 1933, (#2862)

88 Washington Cathedral, gate door handle detail, 1931, (#2862), below

89 Washington Cathedral, gate for the Children's Chapel, 1934, (#3025), above

90 Washington Cathedral, cresting detail for the Memorial Screen for Justice Fuller, 1934, (#3124), right

91 Equitable Trust Co., interior of the bank, 1926, (#2600)

92 Equitable Trust Co., Yellin inspecting a bank screen prior to shipment

93 *Bok Singing Tower, bronze entrance door to the tower depicting the Seven Days of Creation, 1928, (#2779)*

94 *Bok Singing Tower, bronze repoussé panels prior to their assembly on the door*

95 Bok Singing Tower, interior stairs leading to the elevator

96 Gate for the Bok home which was later installed at the Curtis Institute, 1927, (#2722)

97 A special gift for Mr. Bok from Mrs. Bok

98 A letter box that Mrs. Bok used at the Curtis Institute, 1929, (#x2185), below

The Bok family patronage covered almost the entire career of Samuel Yellin. Mr. Bok and Yellin became good friends when the Carillon Singing Tower was first commissioned. In a telegram, Bok asked Yellin to join him for a trip to visit the tower in his private train car, the "Orange Blossom Special." They were joined by Milton Medary, a Philadelphia architect, who was designing the tower. (The gate, # 2981, pg. 60, was made by the men in the Yellin shop on their own time as a memorial to Medary.)

Other members of the Bok family also commissioned Yellin to do work for them. They much preferred to have Yellin's artistry and whimsy rather than purchase items from a department store. An example is the letter box that Mrs. Bok had Yellin do for her office at the Curtis Institute of Music. She requested that it be made so the papers do not blow around in the breeze. The dog hinges down to hold the papers.

99 *Curtis Institute of Music, entrance gate, 1927, (#2717)*

100 *Curtis Institute of Music, entrance gate detail*

101 J. P. Morgan Library Annex, grille, 1928, (#2/21)

102 J. P. Morgan Library Annex, screen

104 New York Life Insurance Co., grille, 1928, (#2812)

103 W. K. Dupont residence, gate, 1928, (#2790)

105 Bryn Mawr College, lamp on Goodhart Hall, 1928, (#2733)

106 University of Pennsylvania Museum, entrance gates, 1928, (#2744), below

107 *Central Savings Bank, section of cresting,*
1928, (#2750)

108 *Central Savings Bank, exterior gates*

109 Melville G. Curtis residence, stair railing and lamp posts, 1928, (#2711)

110 Edsel Ford residence, exterior doors, 1928, (#2773)

111 Harry B. Little residence, garden gate, 1928, (#2469)

112 Frank S. Hambleton residence, vestibule door and transom, 1929, (#2907)

113 Baltimore Trust Co., interior gates, 1929, (#2813)

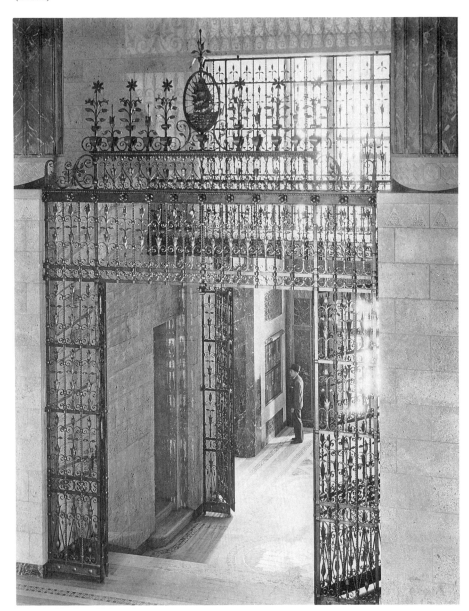

114 Baltimore Trust Co., crest on interior gates

115 Baltimore Trust Co., newel post stair and handrail

116 Citizen's Bank of Weston, entrance gates. 1929, (#2840)

117 Citizen's Bank of Weston, interior gate, below left

118 Citizen's Bank of Weston, interior, below

*119 Redlands Cemetery, entrance gates, 1929,
(#2842)*

*120 P. W. French & Co., section of stair
railing, 1929, (#2854)*

121 P. W. French & Co., section of stair railing

*122 P. W. French & Co., section of stair
railing*

123 George W. Olmsted estate, entrance gates,
1930, (#2896)

*124 McKinlock Memorial, Northwestern
University, 1930, (#2864), previous page*

*125 McKinlock Memorial, Northwestern
University, detail of cresting*

*126 Hall of Fame, New York University, gate,
1930, (#2931)*

127 B. D. Phillips residence, top portion of torchiere lamp, 1930, (#2913), right

128 B. D. Phillips residence, exterior monel lantern, below

129 B. D. Phillips residence, wall sconce, below right

130 B. D. Phillips, assembly drawing, top left portion of this drawing is the torchiere in fig. 127. (photo by Will Brown)

*131 James Norman Hill Mausoleum, exterior
monel door, 1930, (#2900)*

*132 Divinity School, Medary Memorial Grille,
1931, (#2981)*

133 Grace Cathedral, screen, 1931, (#3016)

134 Grace Cathedral, lock detail, below

135 Grace Cathedral, cresting detail, bottom

136 Harvard University, Eliot House gate, 1931, (#3018), left

137 Harvard University, Eliot House gate with transom, below left

138 Harvard University, Vanderbilt Hall gates, 1931, (#3055)

139 City National Bank, interior glazed door, 1932, (#3056)

140 City National Bank, interior glazed door detail

141 *Cathedral of St. John Divine, hardware
on wood reredos doors, 1937, (#3203)*

142 *Cathedral of St. John Divine, hardware
on wood reredos doors*

144 *Federal Reserve Board Building, interior doors*

143 *Federal Reserve Board Building, newel post and stair rail, 1937, (#3205)*

145 *University of Pittsburgh, exterior gate,*
1937, (#3214)

146 *University of Pittsburgh, exterior gate*
pivot detail

147 University of Pittsburgh, Cathedral of Learning, railing in the commons room , 1937, (#3210), above

148 University of Pittsburgh, Foster Memorial Library, hardware on oak doors, 1938, (#3233), right

149 University of Pittsburgh, Heinz Memorial chapel, hinge on doors, 1938, (#3250), below right

150 Brick Presbyterian Church, portable pulpit, 1940, (#3274), which may have been one of the last pieces Yellin designed.

man of great creativity, conviction, drive, and determination, Yellin had an endless source of energy. He was a kind and generous person. His demeanor when among others, was always friendly and humorous. Jerry Geerlings spoke very highly of him; he related that, when he and his wife were on their honeymoon in Paris, the Yellins invited them to dinner. He was quite surprised with this kind gesture for he was a junior architect at York and Sawyer at the time. Geerlings also related the times that Yellin would come to the New York studio to check out the work on the Federal Reserve job. "Yellin would come into the studio and chat and talk to everyone; in no time at all, even the dour old Mr. Sawyer, would be laughing."[28]

Yellin would have dicussed with the architects, in the studio, his favorite topic, "Craftsmanship," for it was an issue that he always addressed.

151 Yellin standing at the entrance gate to the Arch Street studio; this photograph was taken at the same time as the photo on the frontispiece. Even thought his collar is a bit askew, he was an impeccable dresser. He always wore a suit with vest, starched collar and tie, usually with spats and polished shoes. In the forge he always wore a shop coat to protect his clothes.

Craftsmanship

*Y*ellin spoke frequently to architectural and art groups on the subject of craftsmanship. The following lecture, "Design and Craftsmanship," was given before the Architectural Club of Chicago, in Chicago, on March 9, 1926. This lecture, along with several others, was typed and placed on file in the office; most of these talks were titled "Craftsmanship." Of his lectures this one mentions the full range of topics that he usually discussed. To point out the topics that were discussed most frequently and that the author feels are important, a symbol (↔) has been placed opposite the paragraph where that issue is addressed.

The lectures usually ended with a show of "lantern slides." These were 3 1/4 x 4 1/4 glass mounted slides of the Yellin wrought ironwork, as well as antique and contemporary metalwork.

Ladies and Gentlemen:

It is a great pleasure for me to be here and to have the opportunity of speaking to you and with you on the subject of "Design and Craftsmanship" and in particular about the noble material "wrought iron." I hope you will accept what I have to say in the right spirit and if I do put some things before you rather strongly, nevertheless they are very true, and I am prepared to prove the facts.

It is unfortunate that the real nature of craftsmanship, the use of materials in a way appropriate to their nature—for ends to which they are well adapted—is little understood today.

To begin with, let us ask ourselves this question: "What is craftsmanship?" Is it to make work by inventive and tricky methods in original designs that will make the public marvel at the workman's cleverness because they cannot see how it was done? Or is craftsmanship working out good designs in the proper material and in the honest way?

I think it is of the utmost importance for architects and art lovers who are the teachers of art in general, to insist and demand proper designs for the various materials and see that they are correctly executed. This is the only way the arts can be worthy of their names.

I find that the public is becoming more and more interested in good work in various lines of art. If a man is truly an artist, he must impose on an unwilling public standards of perfection to which it is not accustomed.

If architects are really interested in obtaining the best decorative metalwork (which I call the salt and pepper of architecture), it will be necessary for them to change their methods of procuring same. The most important thing to do is to make the question of bids and competition as the least essential, and thereby eliminate the writing of unnecessary and useless specifications. Very often architects tell me that they have to do this because their clients insist. But this is where the architect must perform his real duty and cultivate the client's mind and eye so that he will learn to be discriminating and appreciative of beauty. Thereby he will learn to accept the better work, even though the cost might be greater, or the designs will have to be simplified to meet the set allowance. I have proven this to many architects in connection with my work, and I feel that others can do likewise.

In order that an architect may obtain the best results he must or he should follow the procedure which I suggest; select the men whom you think capable both as designers and craftsmen—and not those who specialize in salesmanship and whose work is turned out in wholesale quantities. Ask them to submit to you suitable sketches for the work contemplated. These sketches must always indicate that the man understands

thoroughly the style of architecture, so that the particular unit or units may be in keeping with the rest of the work. After these sketches are acceptable, full size studies should be submitted together with a fragment of the actual work. I believe that any true craftsman would be willing to work along these lines. I feel that these suggestions ought to appeal to you because they are practical. This is a much simpler and more direct method than to write specifications which are meaningless.

Sometimes architects spend a good deal of time and money in making models in clay for ironwork. Iron cannot be modeled in clay and it would be much better and safer to spend that amount of money on the actual work. Metalwork can only be suggested on paper, but the actual life, character and beauty depends upon its making. The very best way of working is to make sketches in the actual iron on the anvil and let them serve as the inspiration and character of the work contemplated. Then the drawing can be made. This is the method I use and it has always been satisfactory. Besides it not only gives me exercise, but also puts blisters on my hands.

There is only one way to make good decorative ironwork and that is with the hammer at the anvil, for in the heat of creation and under the spell of the hammer, the whole conception of a composition is often transformed.

The relations between architects and craftsmen should be much closer than they are at present. But I do feel that it is the architect who can make them so. He can always be sure of a welcome to the craftsman's shop. Visit his shop and watch the different stages and methods in the production of decorative metal work. Work with him and learn from him. Gain a greater interest in the work he is doing.

Very often I am asked by architects how work should be specified. I always tell them, "Specify that work should be done in the best possible manner." There is no other form of specification that the true craftsman understands. It has been said to me that all my workers must be artists, but many are no different from other ironworkers, at least when they first come to my shop. But I always insist that all the work which leaves my shop should be honestly and beautifully executed.

It is most important that a piece of work shall be harmonious from every point of view. I mean that, besides being a part of its surroundings, it must harmonize within itself.

When a design is made for a wooden door, it is extremely important in order that the door be completed as one unit, that the trimming be designed in coordination. Very often I receive details of doors and am asked to design hardware. People are disappointed when I write and tell them that a particular door is not suitable for strap hinges, but after receiving a thorough explanation they realize the impossibility of their intentions. ironwork, particularly, requires background if it is to count as a decorative feature. Many times I have persuaded some of my clients to omit other decorations such as stone carvings, etc. in order that the decorative iron itself should have a background and play its part.

I have seen people looking at a grille and while they admired one portion they disliked another in the same grille. This at once stamps it as a bad piece of work, for it shows the fact that the maker had specialized in one part of the craft only and betrays that he is not a true craftsman.

The true craftsman should know every branch of his craft and a piece of work can only be either good or bad. If one small part of the grille is bad, the whole grille is bad. For a piece of craftsmanship to be good not the smallest part should receive adverse criticism. And even though twelve men work on one pair of gates they must appear when completed as though they were made by one man. I have been told that I am too particular—too discriminating. I wish to say that it is impossible to be so. If people are allowed to be content with things which they call "good enough," the arts will never reach a high level. If the best is worth seeking, one should be content with nothing but the very best. And the best can be given in a little handle costing $5.00 as well as in a gate costing $10,000. They should both be executed with the same amount of love and yet I receive inquiries such as this:

My dear Mr. Yellin,
Enclosed please find a scale blue print showing an iron balcony. Send us one estimate the way you do it also an estimate the way the other fellows do it.

I am a staunch advocate of tradition in the matter of design. I think that we should follow the lead of the past masters and seek our inspiration from their wonderful work. They saw the poetry and rhythm of iron. Out of it they made masterpieces not for a day

or an hour but for the ages. We should go back to them for our ideas in craftsmanship, to their simplicity and truthfulness. The superficial and the tricky, which are spreading over the world of art like a disease, doom themselves to destruction. The beautiful can never die.

I do not mean that we should copy from books or examples just what they did, but it is advisable to always have their examples before us and to work upon the suggestions made by the best of them. It doesn't do anybody any good to copy anything. The result is never a copy—no such thing exists. It is either better or worse than the original. The work of the old craftsmen is there to be studied for inspiration for one's own creative faculties, and not just to encourage duplicates.

Good design can only be obtained by the process of evolution—and designs which are not based upon some tradition are purely inventive and not creative. Although iron is the least expensive of all metals, there is no other material which lends itself to more beautiful treatment. Neither is there a material which can be worked more quickly. But unfortunately there are many who do not understand these facts. I will give you an instance: some time ago I received from a firm this letter:

> My dear Mr. Yellin:
> We have been commissioned by an architect to make for him a pair of bronze doors, made of wrought bronze, and as you have done work for him in the past, we would like, if not asking too much, to have you send us a small sample of a piece of wrought iron representing the early Italian Period, in order that we may faithfully reproduce this class of work in bronze, etc.

You will note that the proposal was to make doors in wrought bronze and to reproduce early Italian work in bronze. It cannot be done. Bronze, admirable as it is in many positions, and used in the right way and that is to cast it cannot be wrought or worked as iron can. The brazing would have to be done in an artificial and mechanical manner, as would many other details and to those who recognize what is right, it would always appear as something faked. It would be like attempting to make a freehand sketch with drawing instruments. These doors were first modeled in clay and a photograph of the model was sent to me. They were called Italian in design. I replied by this letter:

> Gentlemen:
> I have received your letter, also your photograph which I am returning herewith. I really do not know what I could send you on this particular proposition. The style is not familiar to me at all. If I may criticize, it is not Italian and the design is modified in such a way that you could work directly from the model and very safely obtain the effect you desire.

It was, I thought, very deplorable that an architect should ask for such work. But the worst has yet to come!

In an issue of the American Magazine of Art there appeared a photograph of these completed doors with an article written about them entitled "A Forged Bronze Door." In a book which by its title claims to further the aims of arts and crafts was published a photograph of an impossibility together with an article which enthused over this impossibility. Bronze cannot be forged. And it is false to attempt to forge it or call it forged. It can be cast and then chased, which I believe, is how those doors were made. The article says that the bronze was rendered as clay and that it has been given the refinement of treatment seen in the most exquisite wood carvings.

Can you not, you who have any sense of the fitness of things—see the horrible contradictions in these phrases? Is it right that metal should be modeled as clay or as carved wood? Does it indicate that the material has been worked as that material should be worked? Does it indicate the craftsman's eye for his material and for his method of working it? The answer is NO!

These doors are a hypocrisy and a falsehood. Above all, despite the fact that the doors are bronze, they do not honestly show it. They are disguised. To quote the article further: "The doors were treated by a special process to give them a silvery tone to represent iron craftsmanship!" The article says that by using bronze the modern craftsman is enabled to go a step further than either the Italian or the Spanish workman. In which direction, I wonder?

As to the design, the letter written to me calls it Italian. The article says that it savors of the early French style; this difference of opinion emphasizes the honest man's view that it belongs to no period but to the present period of bad design and craftsmanship, and to the class which is decadent.

It is so discouraging to find literature to which so many look for their knowledge of art, containing stuff of this sort. But I am thankful that we have the architects who can—if they will—educate the public who does not know what is right in the arts and crafts—to appreciate the truly logically beautiful. And I am thankful that we have these architects who can fight against such bad influences.

Do not blame the public for asking what is bad. Yours is the responsibility, for you are the educators of the public. It is part of your mission to spread the beautiful and to trample under foot all such tendencies as the one I have just quoted. But you must work with united action.

The American Magazine of Art is not alone in exerting this bad influence. In an issue of Arts and Decorations appears an illustrated article entitled "Sonatas in Silver and Ballads in Bronze" is called a disciple of the incomparable Cellini. How Cellini must squirm in his grave.

It is strange, however, that the same publishers illustrate some beautiful old colonial ironwork and this seems to indicate that there is neither a full appreciation of the good work besides the acceptance of the bad. Good Furniture is another periodical that has recently illustrated and advocated metalwork that is no inspiration to craftsmanship.

These various magazines even claim to establish a vogue in the crafts, as they do in the manner of dress. How false this seems.

Recently I served on an art jury which had to select some work to be included in a traveling exhibition of arts and crafts. The general class of articles submitted was very poor and I suggested to the members of the jury that more good would be gained by not carrying out the exhibition than by exhibiting such craftsmanship as was submitted. If it was to be educational, nothing should have been accepted which was not correctly designed for its material and honestly and beautifully executed. Things should not be accepted for exhibition because they are "amusing" or "cute" or because they have a "nice effect." Anything that is done for effect only is bad. The effect of a piece of work must be the undisguised appearance of its material and workmanship, and we should not, for instance, try to give bronze the effect of iron.

Sometimes color is used on metalwork for its effect. Sometimes the decorator wishes to carry his color scheme in lighting fixtures or other metalwork. But, although occasionally a little color or gilt may be used to give warmth to a piece of work, it rather suggests painting the lily. The most logical way to give more color to ironwork is to incorporate another metal, for instance, brass—applied or inlaid, which with the iron itself will make any piece colorful to those with eyes to see it. All of my work is honestly and simply done, whether it be visible in the finished product or not, and the nature of the material is truthfully expressed both in handling and finish; there is no antiquing, or torturing, no rusting, or coloring.

Throughout my life I have been striving to teach people the love of beautiful things. There is no reason why people in the United States should fancy that we cannot do beautiful things here, because we can. Only America has been used to accepting the superficial, that the workers turn it out in bulk.

It is with keen interest that I look forward to the advancement of much better work in every line of art, and feel that the only way this can be attained is to begin at the very foundation, that is, it should begin with the architect who has so much to do with art in general. Let us better educate ourselves whenever we may have an opportunity. The best can be just as easily procured as that which is not quite as good.

Then too, it is now the opportune time for the establishment of good schools, where our young boys could learn to love and make beautiful things under the supervision of masters only.

Another suggestion for creating good craftsmen and craftsmanship is to have juries, composed of masters, judge work at the time when exhibitors submit the various crafts for exhibition; to reject everything that is not correctly designed for its material and honestly and beautifully executed in its material. Such rejections should be accompanied by a letter of advice and criticism. This I feel sure would improve conditions greatly, for to my mind, one who is really sincere about his work would profit by this and determine to do better in the future.

Let us remember that "a thing of beauty is a joy forever."

Speaking about schools, I have something very interesting to tell you.

For the last ten years I have been talking to many people about the necessity of a real craftsman's school. I am glad to tell you that plans for such a school are now under way. I am planning to have this in conjunction with my shop, or near my shop, where I can devote a good deal of time to it and have some of my good boys help me to teach our boys to learn to love and create beautiful things in metal. Eventually we will include its sister material—wood. Only those boys will be admitted who will prove to me that they really want to learn.

You no doubt have heard about the Bok Civic Award, which by some "mistake" has been conferred upon me this year. With this award came a check for $10,000. This money will be invested and the interest from same (or possibly more) will enable a worthy boy studying with me to go abroad and study the fine old metalwork in the European museums. This will be of great help to them in their future work.

I hope to have the time and pleasure of coming here again to discuss the question of beautiful things which are one of the most essential things today, and which help to make life much more interesting.

I will now show some lantern slides.

152 Wrought iron demonstration piece forged by Yellin for a film made by the Metropolitan Museum of Art in 1929

Wrought Iron Selections

The following selections of wrought iron have been chosen to show the great variety and wide range of the metal art that was created in the Yellin shop. Dates and jobs numbers are given to establish the relative place in which these pieces were created.

Harvey Yellin mentioned that his father's favorite iron piece was the fire screen below. He related that it was the piece that his father thought his best design and he would make no changes to it. It was made around 1926 and took several men six months to complete.

153 Yellin fire screen and fire tools in the Arch Street studio

It seemed that various spaces in the studio were designed to show these wonderful samples of the Yellin design and masterful use of wrought iron to establish a sense of scale and presence to the architecture.

The main entrances to the Yellin shop were arched doors. The two photographs below are of the repoussé paneled door which was in the north west corner of the Arch Street building. This entrance leads into Yellin's room. The photograph on page xv is this door. The two rooms in the museum are separated by a door (fig. 156).

154 Repoussé door, exterior entrance to Yellin's room, reverse side, interior

155 Repoussé door, exterior entrance to Yellin's room, front side, exterior

156 Door separating the two rooms in the museum in the Arch Street building

157 George Memorial, St. Paul's Church, fragment, 1928, (#2713)

158 Pennsylvania Museum of Art, study, never commissioned

159 Edgar Kaufman, headboard for bed, 1925, (#2408)

162 Seaman's Bank for Saving, tellers sign, 1926, (#2546)

163 N. F. Brady residence, fire tool, (no job #), right

160 Bishop Rhinelander, crosier, 1921, (#1931)

161 Edward W. Bok, fireplace equipment for the Maine house, (no job #), below

165 W. M. Jefrords, fireplace wood storage box, 1927, (#2747), below

164 James A. Farrell residence, fire screen, 1919, (#1695), above

166 R. T. Walder, fire screen, 1929, (#x2149)

167 Robert M. Catts, firescreen, 1923, (#2255)

167 *George Eastman House, interior grilles, 1924, (#2334), below*

168 *George Eastman House, interior grilles detail study, above*

170 Carlisle residence, window grille, (#2033)

172 L. J. Kolbe residence, interior gates, 1926, (#2601)

171 Pillsbury residence, interior door, 1919, (#1677)

173 *Bingham residence, lunette grille, 1918, (#1653), above*

174 *St. Thomas Apostle Church, canopy, 1923, (#2191), left*

175 *George B. Melcher, door grille, 1924, (#2282), below*

176 Sears estate, lunette grille, 1922, (#1993), above

177 R. B. Mellon residence, archway over entrance gates, 1929, (#2922), right

178 Unidentified archway, below

179 Guggenheim residence, entrance doors, 1916, (#1574)

180 Stout residence, gate, 1918, (#1676)

181 Detroit Institute of Arts, exterior gate, 192 (#2525)

182 Carlisle residence, entrance doors, 1922, (#2033)

183 St. Andrew's Chapel, memorial gate, (no job #)

184 American Radiator Co., exterior door, 1925, (#2409)

185 Church of the Redeemer, altar rail, (#3042)

186 Burke residence, 1920, (#1721)

187 Unidentified gates, below left

188 Wharton Sinkler residence, 1928, (#2793), below right

189 Daily News Building, interior grille, 1923, (#2089)

191 East 175th St., 1929, (#2855)

190 Newbold estate, 1924, (#2293)

192 (no job #)

194 George Matheson, decorative nails for card
table, 1925, (#2457)

195 Crocker residence, keys blanks, 1927, (#2636)

196 *Theo. Pitcairn estate, hardware for wooden door, 1931, (#3005), left*

197 *Col. Poole residence, door hardware, 1917, (#1562), below*

198 *St. Georges's Chapel, iron door hardware, 1927, (#2678), right*

199 *E. J. Kaufmann Jr. residence, door cane bolts, 1925, (#2408), below left*

200 *Theo. Pitcairn estate, hardware for wooden door, 1931, (#3005), below right*

201 Newbold estate, stair railing and lantern, 1924, (#2293)

203 J. L. Ketterlinus, stair railing, 1923, (#2125)

202 Newbold estate, stair railing and newel post

204 Wm. K. Vanderbilt residence, stair rail, 1927, (#2621)

205 R. Skelton residence, stair railing, 1929, (#2828)

206 R. Skelton residence, newel post for stair railing

207 *W. K. Vanderbilt, balcony, 1927, (#2621)*

208 *Clarence Dillon, residence, 1928, (#2817)*

209 Stephen C. Clark, railing and gate, 1924, (#2037)

210 Sarasota Court House, balcony, 1925, (#2549)

211 *Unidentified grilles*

212 *Unidentified gate*

213 R. W. Sears, wall sconce, 1922, (#1993), right

214 St. Patrick's Cathedral, reliquary, 1928, (#2800), below left

215 St. James, memorial candelabras, (#2491), below right

216 Dr. Milligan, wall sconce, 1926, (#2541), left

217 Mrs. Robert McLean, floor lamp, 1931, (#3052), below left

218 Church of the Good Shepherd, 1923, (#2237), right

219 Unidentified wall sconce

220 B. W. Morris residence, exterior lantern, 1920 (#1779)

221 Edgar D. Kaufmann, brass lavatory fixture, 1925, (#2408)

222 W. K. Vanderbilt residence, exterior lantern, 1927, (#2621)

224 Hill School, memorial lamp, 1927, (#1900)

223 Unidentified candelabra, above

225 St. John's Cathederal, chandelier, 1928,
(#2810), left

226 McQune estate, entrance gates, 1929,
(#2860), opposite page top

227 H. G. Lloyd estate, entrance gates, 1917,
(#1557) opposite page bottom

228 Stout residence, main entrance gates, 1918, (#1692)

229 CalvinWinthrop, entrance gates, (no job #)

230 Passaic National Bank, bank screen, 1925, (#2058)

231 National Park Bank, bank screen, 1925, (#2369)

The drawings created in the Yellin studio were of different types for specific uses. The drawing of the "sketches in iron," page 30, represents the type of drawing that would be done for the creation of new idea. There were probably many of these types of drawings, but few survive. The drawing below is a more refined drawing which was used to check out the details of the iron and how it would relate to the site. (Note the profile of the stone moulding on the right hand side.) This type of drawing was done to allow the smiths to forge the final wrought iron test pieces, prior to the completion of the assembly drawings. The drawing on page 59 represents a final assembly drawing.

The drawings of the weather vanes (figs. 233 & 234) represent the type of drawing that would be used for presentation to clients. Frequently, a number of sketches would be created for the client. These drawings would always be numbered with an "x" prefix. When the final design was selected this number would be replaced with a job number, as on the drawing on the next page.

232 Washington Cathedral, Children's Chapel, 1934, (#3025), pencil drawing of finial detail , see page 41, fig. 89

233 Smith's garage, suggestions for weather vane, 1923, (x1592 to #2259)

234 Pencil drawing, (no job #)

235 Weather vane, (no job #)

Tribute to the Men of the Workshops

Memorials or milestones do not always give the totality of a tribute. Imagine that any one individual could forge and assemble the iron work that came from the Yellin workshops; it is beyond the imagination. But, when you visualize the men in the process of creating this magnificent collection of wonderful ironwork, you can begin to envision what the studio and forges were like. There were the smiths that forged the fanciful animals, gargoyles and scrolls, the fitters that put the pieces together, the repoussé artisans who made flat sheets of metal come alive, the polishers who massaged the surfaces of the metals to glow with color and light, the designers and draftsmen who sketched and drew these same figures and the superintendents who led the work through to completion.

No, this was not the work of one man; it was the sum total of the force of one man orchestrating all of these artisans and craftsmen into producing their best. They did!

Their tribute is the excellence of their work, craft and art which they have left us to appreciate today and, hopefully, far into the future. For this we thank them.

236 The men of the shop posing in front of a recently completed gate for the Washington Cathedral, St. Mary's Chapel, 1933, (#2862). There were an average of 50 men in the shop during this time. The photograph is from a damaged cellouse nitrate negative.

Epilogue

237 Packard Building, bank interior, 1924, (#2313)

Buildings and residences are graced by the wrought iron artistry of Samuel Yellin; this work persists because of his dedication and love of his art. It also exists because of the respect of the many people who admire it today. Yet there is a great danger that much of this past work will be lost to the elements. There is the danger of corrosion (rust) and lack of care; but these problems are relatively easy to solve.

A more serious problem is the lack of recognition of the wrought iron work of the past and its place in our world, along-side the art of today. The photograph above is from the interior of the bank in the Packard Building (pg. 36) which was built in 1924. It is on the corner of Chestnut and 15th Streets in Philadelphia. The wrought iron tables and teller's grilles along with all of the exterior window grilles were removed in the 1970's, because the bank management was advised that these types of furnishings were not suitable. It did not give the image that a bank should present. Most of the work was removed and much of it junked. We may not agree with the views of others or like all of the art work that is in the buildings and museums, but it is certain that we should examine how we care for the art work of the past and not destroy an important part of our cultural heritage.

Ritter and Shay, the architects for the Packard Building wrote the following specifications for the main entrance gate on the construction drawings. They gave him completed control of the design and specified: "See Yellin for all gate details." Since Yellin is no longer around to care for his work we must find others who will.[29]

Can we be the guardians of our wrought iron heritage?

Notes

◦ Samuel Yellin, "Notes of Interest Regarding Samuel Yellin, Esq." (Philadelphia, Yellin Archives, 1937).

§ Richard J. Wattenmaker, *Samuel Yellin In Context*, Revised Edition (Flint Institute of Arts, 1985), pp. 7, 29.

❧ Albert A. Klimchek, *Samuel Yellin 1885-1940*, a quote by Philip C. Elliott (University of Pittsburgh Alumni Magazine, 1940), p 22.

1. Conversation in 1985 with Harvey Yellin, in which he stated that there was little information known about his father's early life and travels in Europe.

2. Transcript of a newspaper article by Mary Theresa Collins, "Samuel Yellin: A Modern Master of an Ancient Art,"1915 (Philadelphia, Yellin Archives), p. 3. Many articles in the Yellin Archives were typed copies of the original material.

3. *Bulletin of the Pennsylvania Museum* (Philadelphia, 1907), p. 34.

4. Article in an unidentified newspaper clipping, (Philadelphia, Yellin Archives). Frequently newspaper clippings and magazine articles in the Yellin Archives were clipped without the masthead, title, or the date intact.

5. Conversation in 1984 with Donald Streeter, who related how Yellin's presence and charm influenced him to change from "Illustration" into "Metals"at the Museum School. He said that there were several women in the class.

6. Collins, "Yellin, A Modern Master," p. 3.

7. Ibid., p 4.

8. Correspondence to York and Sawyer, October 21, 1919, from Cass Gilbert states, "It gives me great pleasure to introduce...Samuel Yellin, whom I consider the master worker in ornamental wrought iron..." (Philadelphia, Yellin Archives). This introduction lead to the commission for the Federal Reserve Bank of New York.

9. Unidentified newspaper clipping (Philadelphia, Yellin Archives).

10. Sandra Lee Tatman, "A Study of the Work of Mellor, Meigs & Howe," (Thesis, University of Oregon, 1977), p. 15.

11. Collins, "Yellin, A Modern Master," p. 4.

12. Conversation in 1983 with Francis Whitaker at the time of the first Yellin Workshop held in the Arch Street forge.

13. Unidentified article, (Philadelphia, Yellin Archives).

14. Transcript of an article by Samuel Yellin, "Modern American Ironwork," Country Life, October, 1925 (Philadelphia, Yellin Archives), p. 15.

15. Transcript of undated article, "Poet of Iron" (Philadelphia, Yellin Archives), p. 3.

16. Yellin, "Modern American Ironwork," p. 11.

17. Transcript of a lecture given at Carnegie Institute, Pittsburgh, PA, May 19, 1925, by Samuel Yellin, "Craftsmanship" (Philadelphia, Yellin Archives).

18. Ibid., p. 4.

19. Partially damaged newspaper article, "1931, In Gallery and Studio" (Philadelphia, Yellin Archives).

20. Yellin, "Modern American Ironwork," p. 12.

21. Violet-le-Duc, *Dictionnaire Raisonné de l'Architecture Francais, vol. 6 (Paris, 1866), p. 76.*

22. Yellin, "Modern American Ironwork," p. 12.

23. Philip Hubert Frohman, *A Tribute to Samuel Yellin and His Work*, The Cathedral Age, Vol. ix, #1 (Washington, DC, 1934), p. 9.

24. Gerald K. Geerlings, *Wrought Iron in Architecture* (New York, Dover Publications, 1929), p. 22.

25. Transcript of an article by George Howe, "Samuel Yellin and His Work" (Philadelphia, Yellin Archives, 1924).

26. Correspondence from Arthur Meigs, October 1, 1931, to Yellin saying that, "you get so damnably excited about clippings from magazines, I cannot resist sending you a page from..." (Philadelphia, Yellin Archives).

27. Hanna Tachau, "Craftsmen and Their Relation to Interior Decoration," House Beautiful, (Philadelphia, Yellin Archives), p. 294. A clipping of a partially damaged article.

28. Conversation with Geerlings at his home in 1984 related the details of the studio and his experiences with Yellin.

29. The Samuel Yellin Foundation was established in 1979 to assist in the education of artist/blacksmiths and the preservation of wrought iron.

238 Yellin standing in the interior courtyard entrance to the Arch Street Studio, contact print from a deteriorated cellouse nitrate negative.

⨍ellin Job Cards

The organizational system of the Yellin shop was instrumental in the overall smooth management of the business. Vital to this system were the job cards. Simple in form and with only essential information on them, they were used regularly in the daily operation of the business. The cards could be used to find working drawings, clients, architects, contractors or the types of work done. All of the paper work, photographs, shipping memos, quotations, experimental work, cost accounting and countless other tasks, used the job numbering system. It is as if these cards became the paper backbone of the organization.

Realizing that the job cards hold almost the entire history of the Yellin's working career, a study of these cards was started early in the development of this book. These cards are now included as the index for the book. There are a number of cards which are lost; a few have been reconstructed from existing information by the Yellin office staff.

The exact date when Yellin started this system is not known, but it is certain to have begun early in his career. From the existing cards it may be assumed that the existing version was started before he moved into the Arch Street building. The cards are all the standard 3 x 5 white index cards. Early cards, those before 1913, were added later by taking information from the working drawings. The cards were created on a typewriter, with notes written in both pencil and pen.

Below is a typical card. The first entry DATE was placed in the top left hand corner. It applied to the first job that the shop worked on for that client. In the case of multiple entries of job numbers only the original date of the first job was used. In a few instances there was an entry for a later date, usually along with the description. On many cards the dates were added later; these dates were entered in a ball point pen.

The second entry was the JOB # and it was usually placed in the top right hand corner. Occasional entries will not have the job number in this position

239 Yellin job card, Federal Reserve Bank of New York

113

and will list the job number below with the description of that type of work.

The NAME OF CLIENT was the next entry and was most frequently entered on the red line of the card. Most jobs are listed by the name of the client and or by the name of an organization. Where there was a large commission or where there are multiple jobs, the name of the specific site was listed, e.g., the "Harkness Memorial" (Yale University). No cross indexing was done, so the specific name of that site must be known to find the job card. The ADDRESS of the job was next and was the most often omitted item on the cards. Frequently the address was abbreviated or shortened. There was another journal in which all of the job's addresses were kept.

The name of the ARCHITECT was and the address of the architect was sometimes included. On the smaller residential jobs it was probable that there was no architect on the job and Yellin was responsible for the contact and design. 'Vith larger jobs the architect was always listed with the full address.

The next entry was the CONTRACTOR for the site. It was the entry with the fewest listings.

The individual JOB #s followed along with the DESCRIPTION of each individual piece that was done on that site. The description was usually the name of the type of work, but in some cases short notes were given. On many cards (about 1/3) there were multiple entries of job numbers and descriptions on each card. When the card became full, the remaining data was entered on the back or a new card started. In some cases this entry was simply described as "Work," or there was no entry. The entry NT was used to indicate that there was No Tracing for that job. This would indicate that there was an updating of the cards. Occasionally the "x" numbers would be entered.

Yellin Job Cards as a HyperCard Stack

Sorting or arranging the individual cards is a cumbersome and time consuming task. A better system of working with and analyzing the cards is used in the form the Macintosh program called HyperCard. The basis of the design of HyperCard is the use of the metaphor of a stack of cards that are used in a library card catalogue. (These are the same cards as used for the Yellin job cards.) There are 1048 cards in this stack. An abbreviated version of all of the known cards, which follows in the index, lists the cards, by job number, in chronological order. There may be some disparity between the order of dates and job numbers due to the time when a commission was started. The job numbers, in this study, go up to #3300, which was the last card of 1940. Since Yellin died in October of 1940 it is likely that he was involved in the jobs of that year.

The chart, on page 115, plots the total number of job cards per year and the number of the individual jobs on those cards. It also has the number of employees in the shop from 1909 through 1940, the working years of Samuel Yellin.

It becomes readily apparent that the workshop was on a growth period from 1909 until 1923, except for a slow down period during World War I. It is interesting to note that after 1915, when the Arch Street studio was built, that the growth period accelerated. Another major slow down occurred after 1923, but the numbers went up in 1925 and 1926. This drop in 1923 is most likely the result of a needed recovery period after the completion of the Federal Reserve Bank commission. The shop recovered and moved to a high in 1928. A downward trend in the number of employees starts in 1929. In 1931 Yellin had a major heart attack and the volume in the shop never recovers. This is due to

both the economic conditions and the inability of Yellin to fully devote his energies to the business.

There are two vertical bars on the chart representing the number of job #s and the total number of individual job #s listed on the cards.

A word of caution must be noted here, for the nature of these cards does not begin to suggest the actual volume of work. As an example, the New York Federal Reserve Bank, for which over 200 tons of decorative wrought iron was delivered, has 3 cards with 33 jobs numbers listed. The work on this job in this first phase took 3 years, with other work being done in later years. On a smaller commissions there would be one card and may have one item that might only be only a letter opener.

The number of employees is taken from the payroll journals. This is a better measure of the actual amount of work being done. The journal listed the employees in the following order; the shop, drafting room, office staff and last, the supernumeries, who were used in the installation work and hired when needed. The typical work week was 44 hours.

February, 1928 was the high point; there were 268 employees listed in the following manner: shop 240, 89%; design/drafting 15, 6%; office 3, 1%; and supernumeries 10, 4%.

Chart 1

Job Cards and Number of Employees

Job # Date

Name

City State

240 Layout of the cards in the index, which appear on the following pages